SCHOOL PICTURE DAY

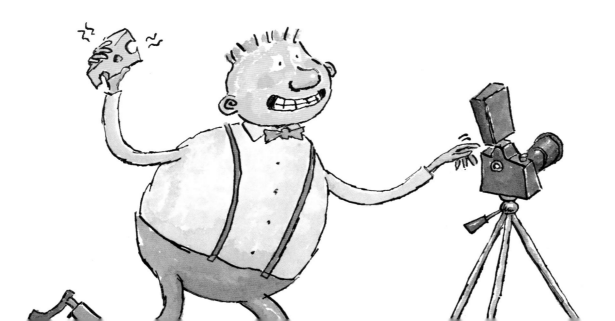

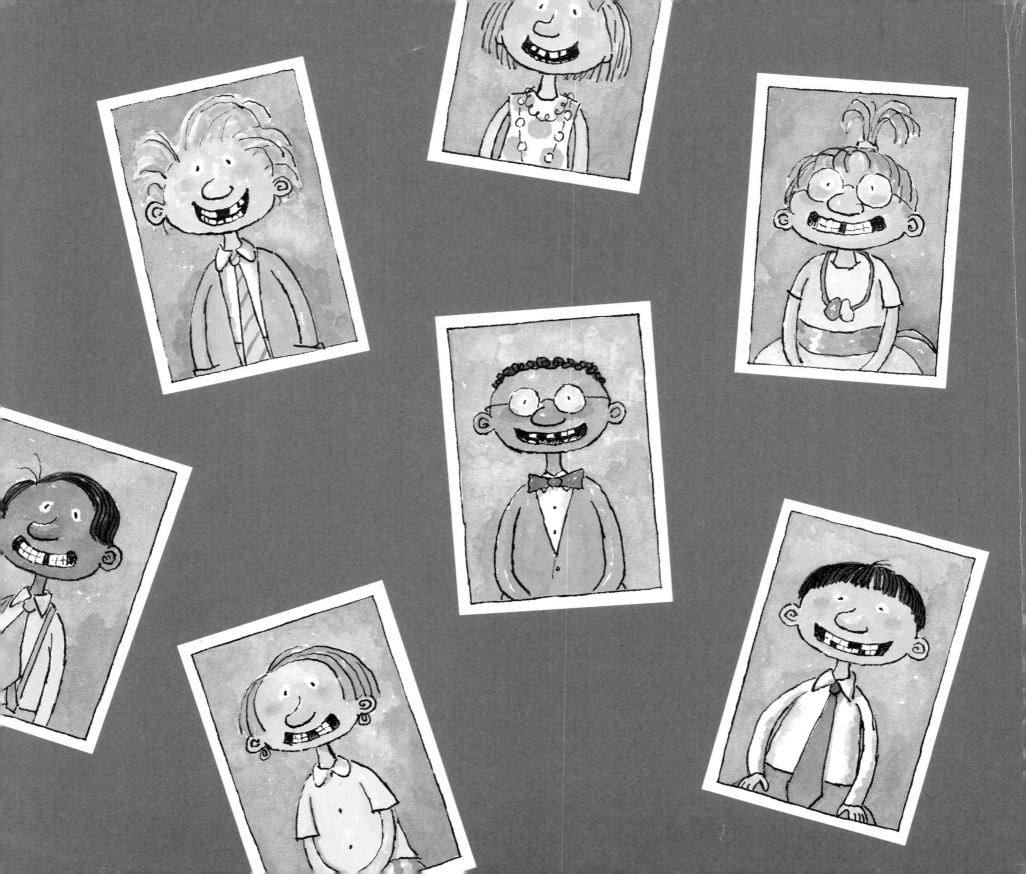

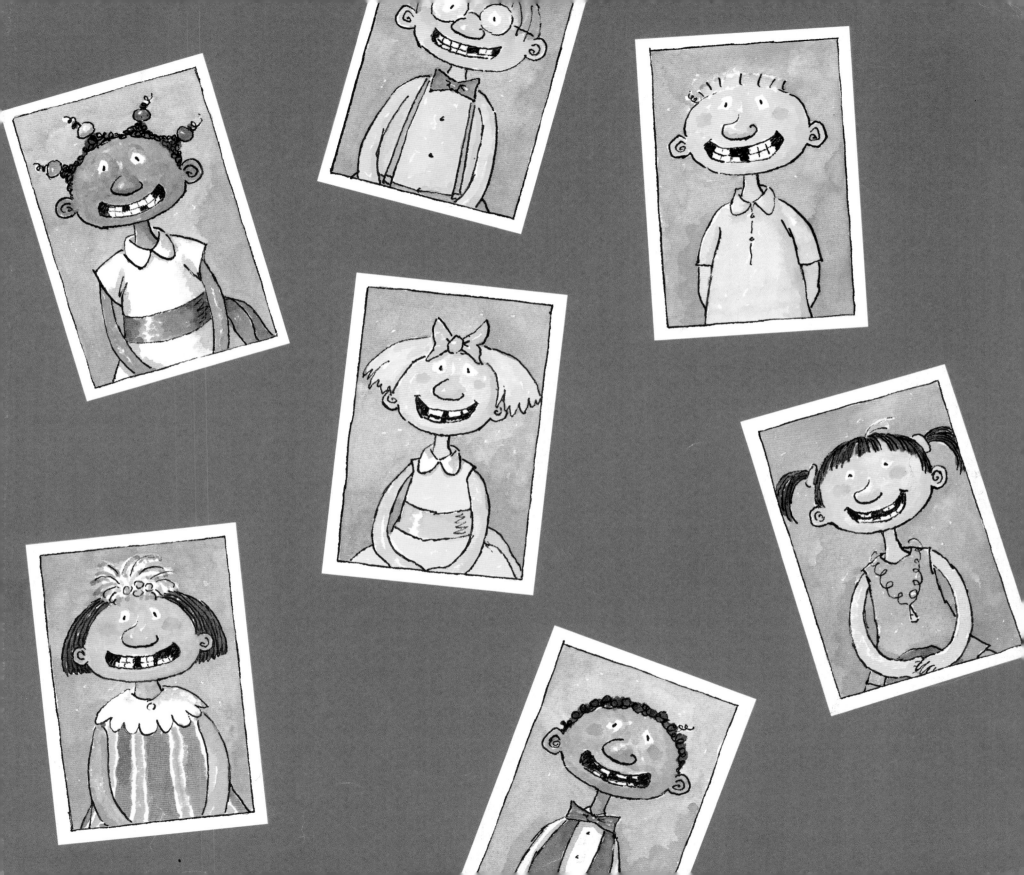

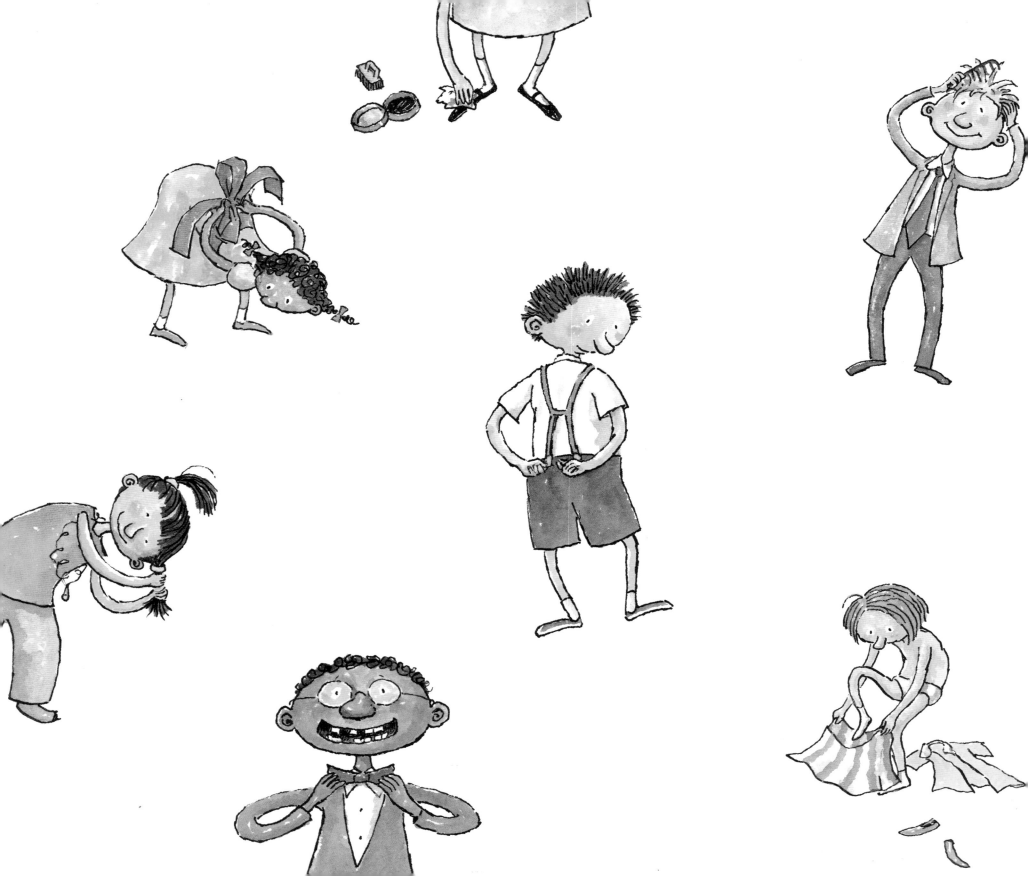

BY
Lynn Plourde

SCHOOL PICTURE DAY

ILLUSTRATED BY
Thor Wickstrom

PUFFIN BOOKS

With love to Seth,

my favorite fidgeter, fiddler, fuddler, foopler

L.P.

To Sara and Stephanie,

who encourage fiddling and fuddling

T.W.

PUFFIN BOOKS
Published by Penguin Group
Penguin Young Readers Group,
345 Hudson Street, New York, New York 10014, U.S.A.
Penguin Books Ltd, 80 Strand, London WC2R ORL, England
Penguin Books Australia Ltd, 250 Camberwell Road, Camberwell, Victoria 3124, Australia
Penguin Books Canada Ltd, 10 Alcorn Avenue, Toronto, Ontario, Canada M4V 3B2
Penguin Books (N.Z.) Ltd, 182-190 Wairau Road, Auckland 10, New Zealand

First published in the United States of America by Dutton Children's Books,
a division of Penguin Putnam Books for Young Readers, 2002
Published by Puffin Books, a division of Penguin Young Readers Group, 2004

10 9 8 7 6 5 4

Text copyright © Lynn Plourde, 2002
Illustrations copyright © Thor Wickstrom, 2002
All rights reserved

CIP Data is available.

Puffin Books ISBN 0-14-240150-1

Manufactured in China

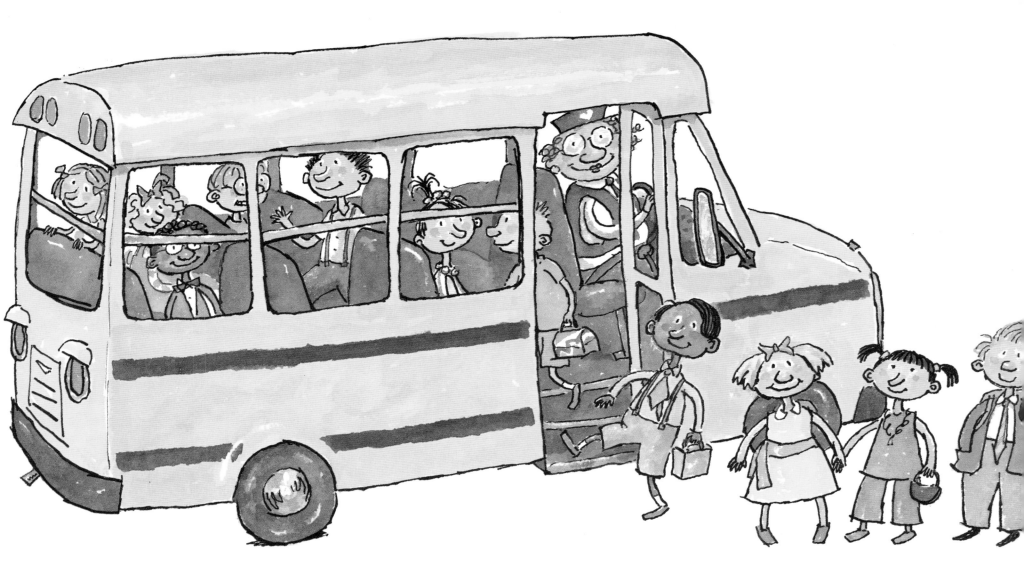

It was school picture day.

Everyone was dressed in their best—
bows and bow ties,
sashes and suspenders,
jewels and jackets.
Everyone, that is, except . . .

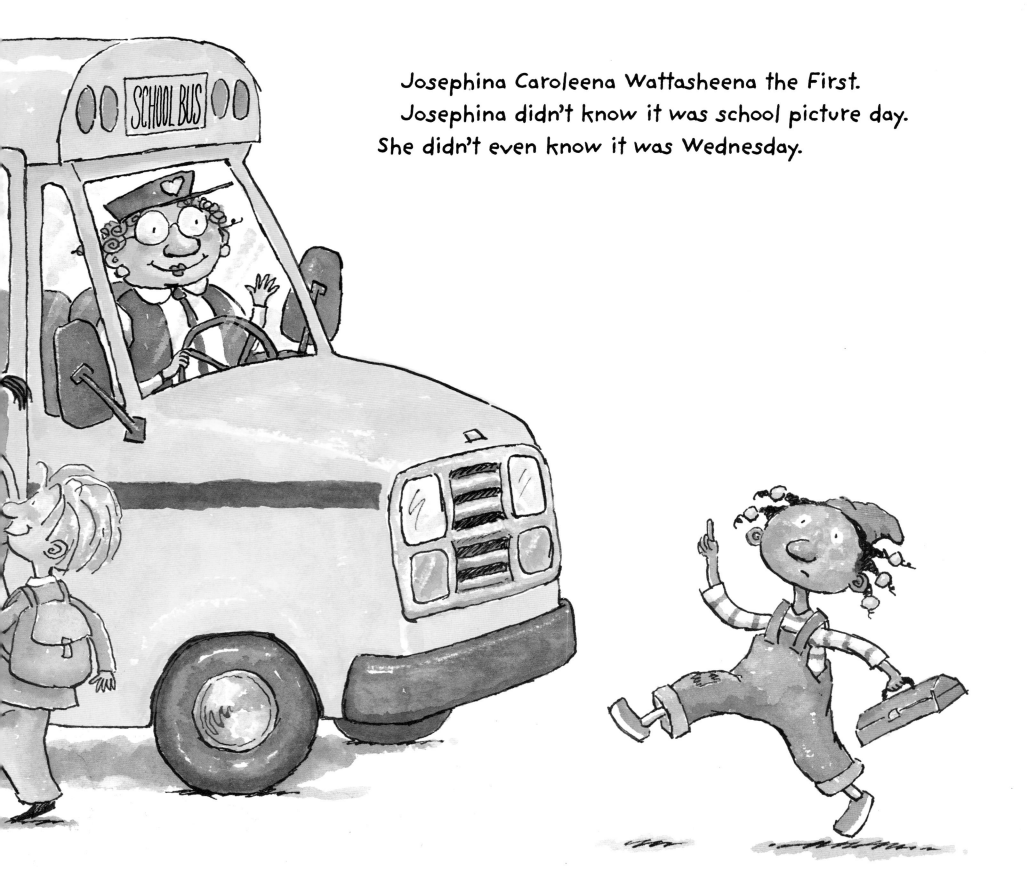

Josephina Caroleena Wattasheena the First.
Josephina didn't know it was school picture day.
She didn't even know it was Wednesday.

She had more important things to think about
on the bus ride to school.

"Hmmm. I wonder how this gearshift works."

SQUIRM

SHIFT

SQUEAL

LIFT

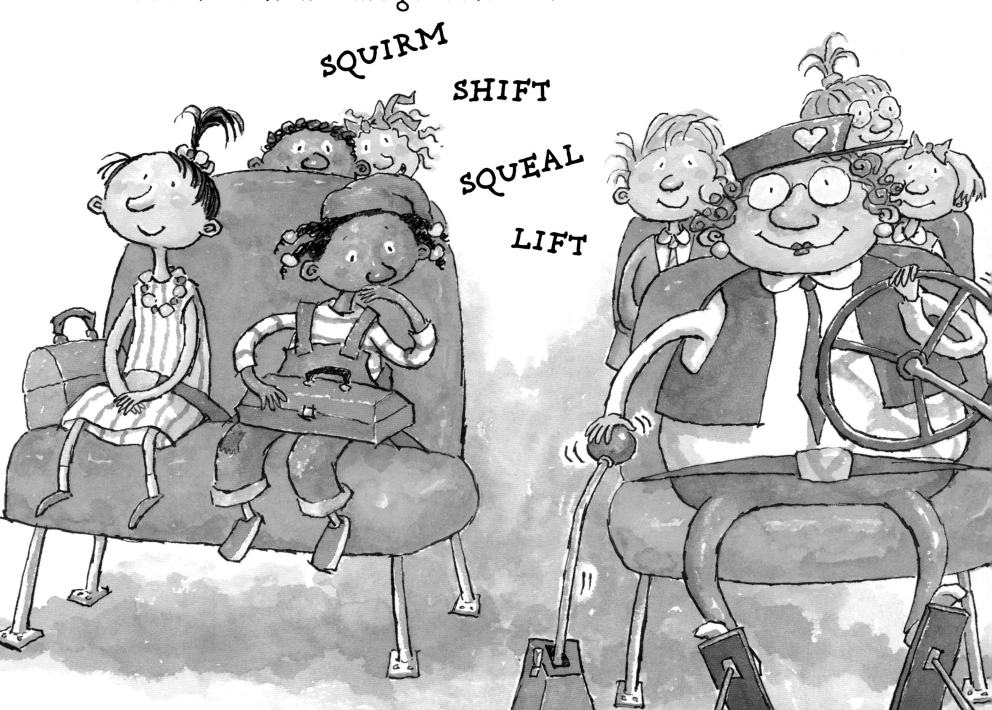

After some highfalutin fidgeting, fiddling, fuddling, and foopling, Josephina finally figured out how the gearshift worked.

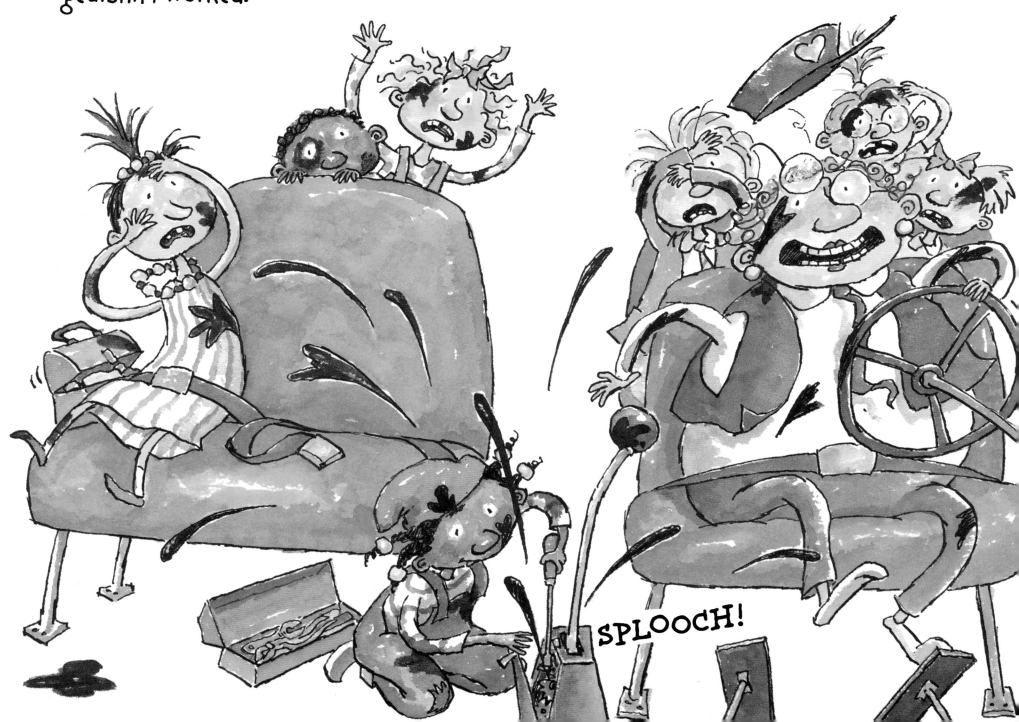

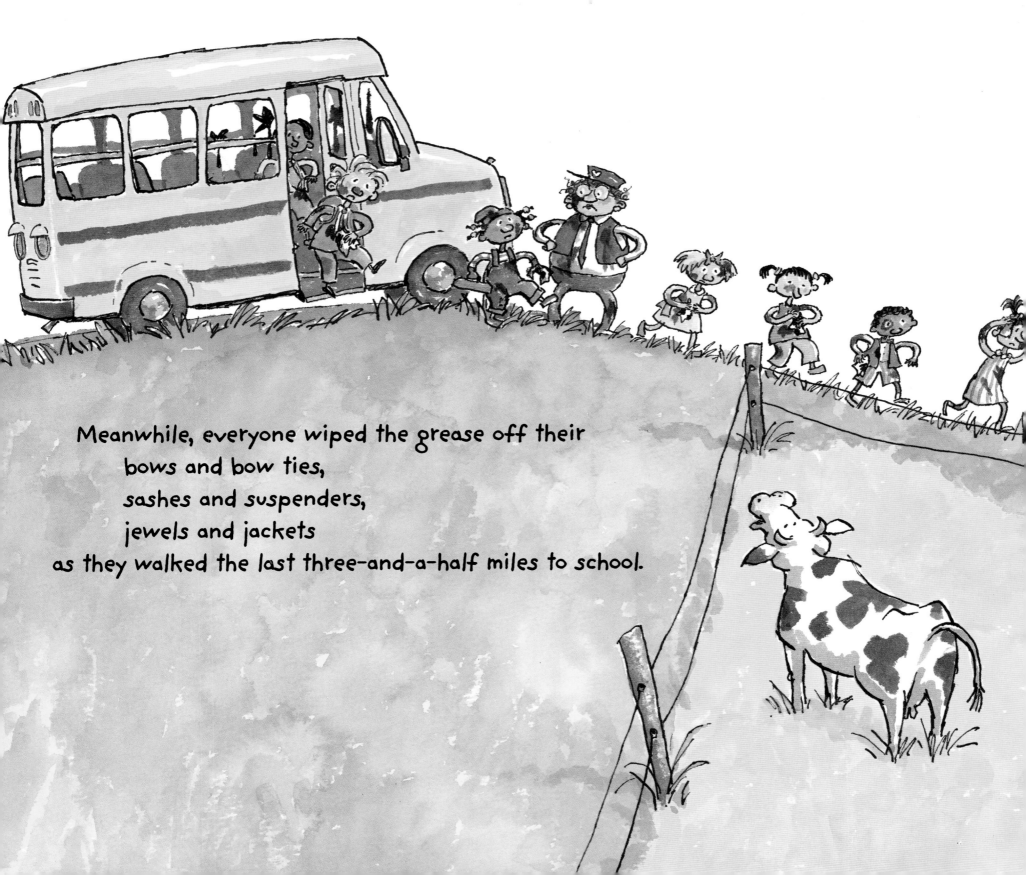

Meanwhile, everyone wiped the grease off their
　　　bows and bow ties,
　　　sashes and suspenders,
　　　jewels and jackets
as they walked the last three-and-a-half miles to school.

"Hustle, bustle, hurry, scurry," said Mrs. Shepherd as she rushed everyone into her classroom. "You're late, and the photographer will be here any minute to take our class picture. Now please, everyone, fill out the school picture form with your sharpest number-2 pencils. . . . And no fiddling," she added with a glance toward Josephina.

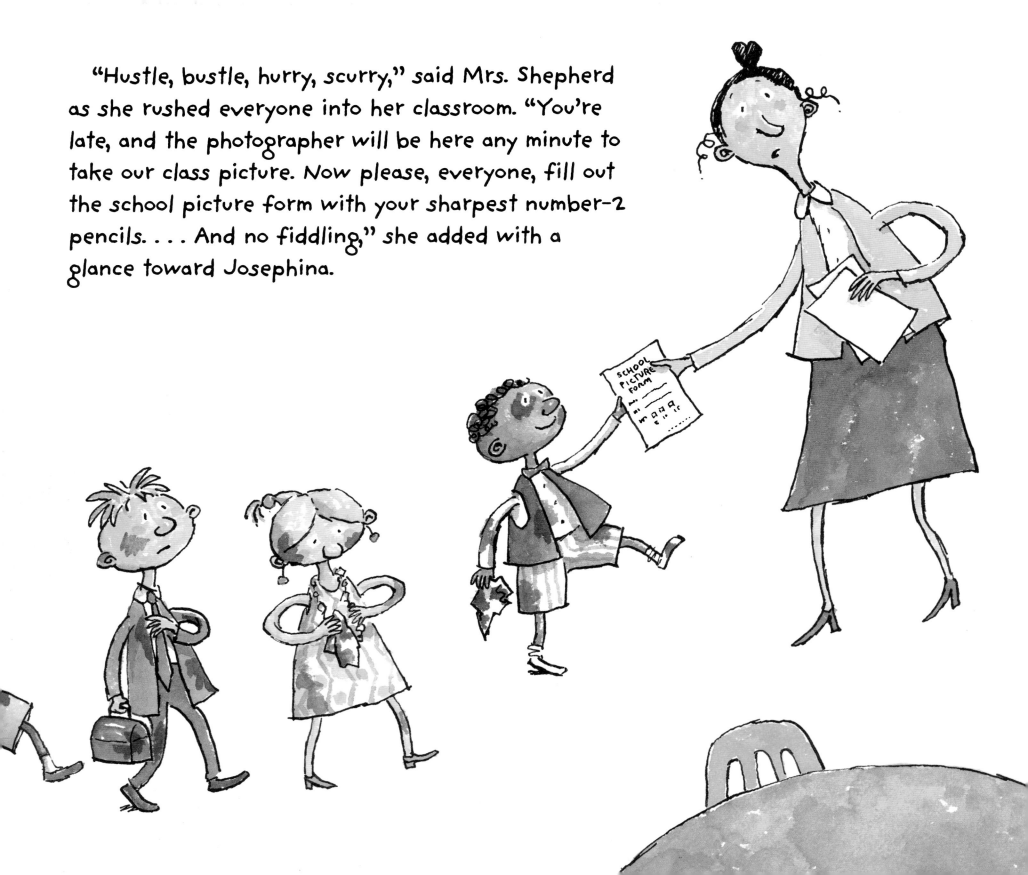

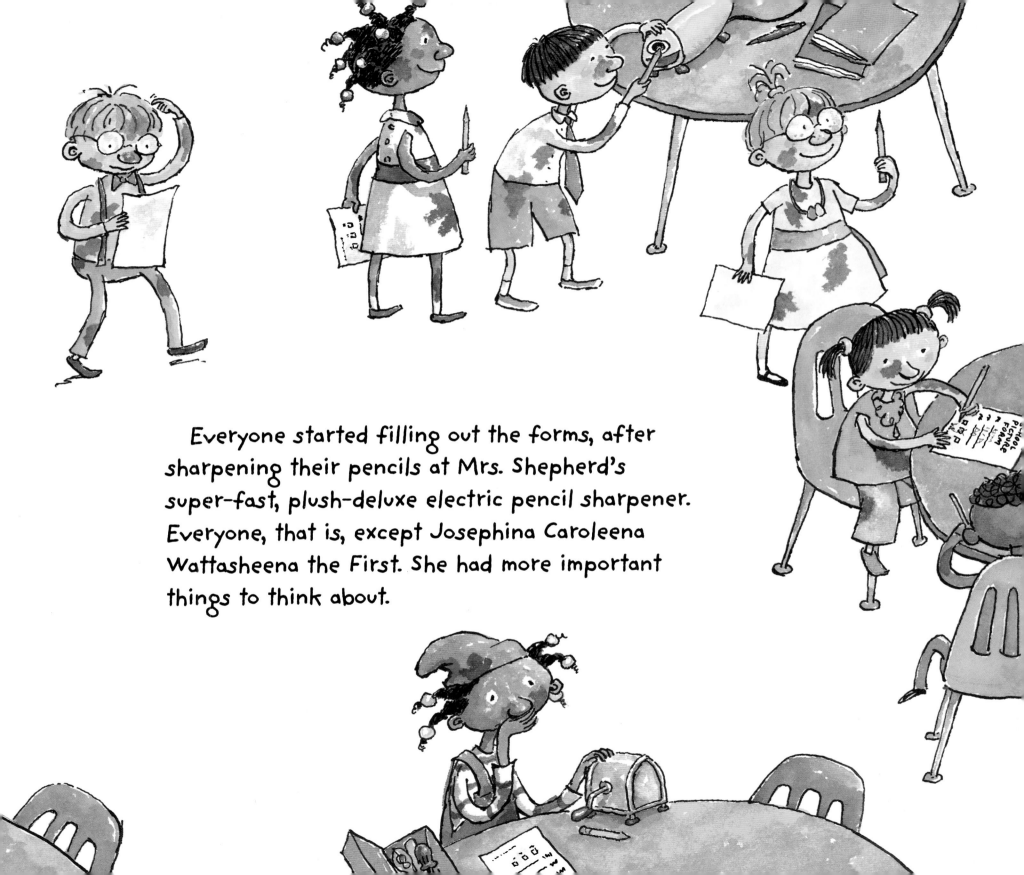

Everyone started filling out the forms, after sharpening their pencils at Mrs. Shepherd's super-fast, plush-deluxe electric pencil sharpener. Everyone, that is, except Josephina Caroleena Wattasheena the First. She had more important things to think about.

WIGGLE YANK JIGGLE CRANK

"Hmmm. I wonder how this pencil sharpener works."

After some highfalutin fidgeting, fiddling, fuddling, and foopling, Josephina finally figured out how the pencil sharpener worked.

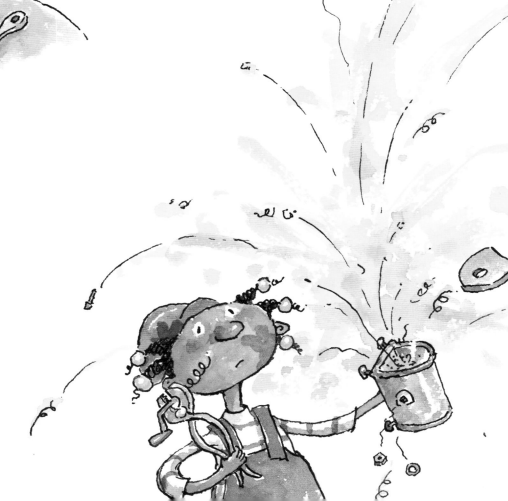

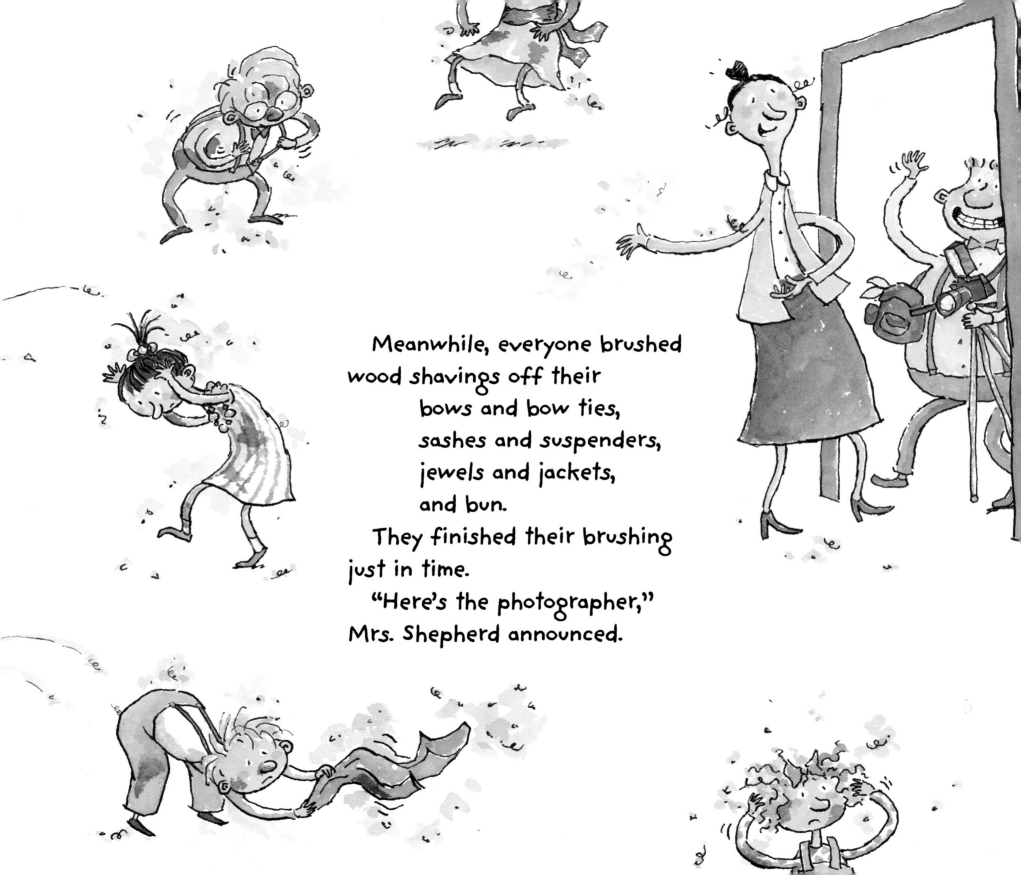

Meanwhile, everyone brushed
wood shavings off their
 bows and bow ties,
 sashes and suspenders,
 jewels and jackets,
 and bun.
They finished their brushing
just in time.
"Here's the photographer,"
Mrs. Shepherd announced.

"Time to line up, you cutesie wootsies." The photographer scurried Mrs. Shepherd and all twenty-three children in the class into their places:

the stand-on-the-chairs row,
the stand-on-the-floor row,
the sit-on-the-chairs row,
and the sit-on-the-floor row.

He put Josephina in the stand-on-the-chairs row, then ordered, "Everyone, say cheesy wheezy, if you pleasy."

"Cheesy wheezy," went twenty-two children and Mrs. Shepherd.

But Josephina had more important things to think about.

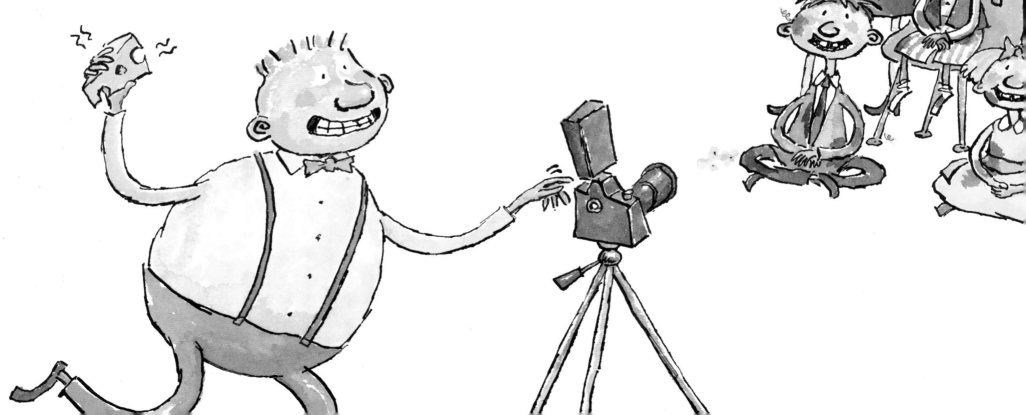

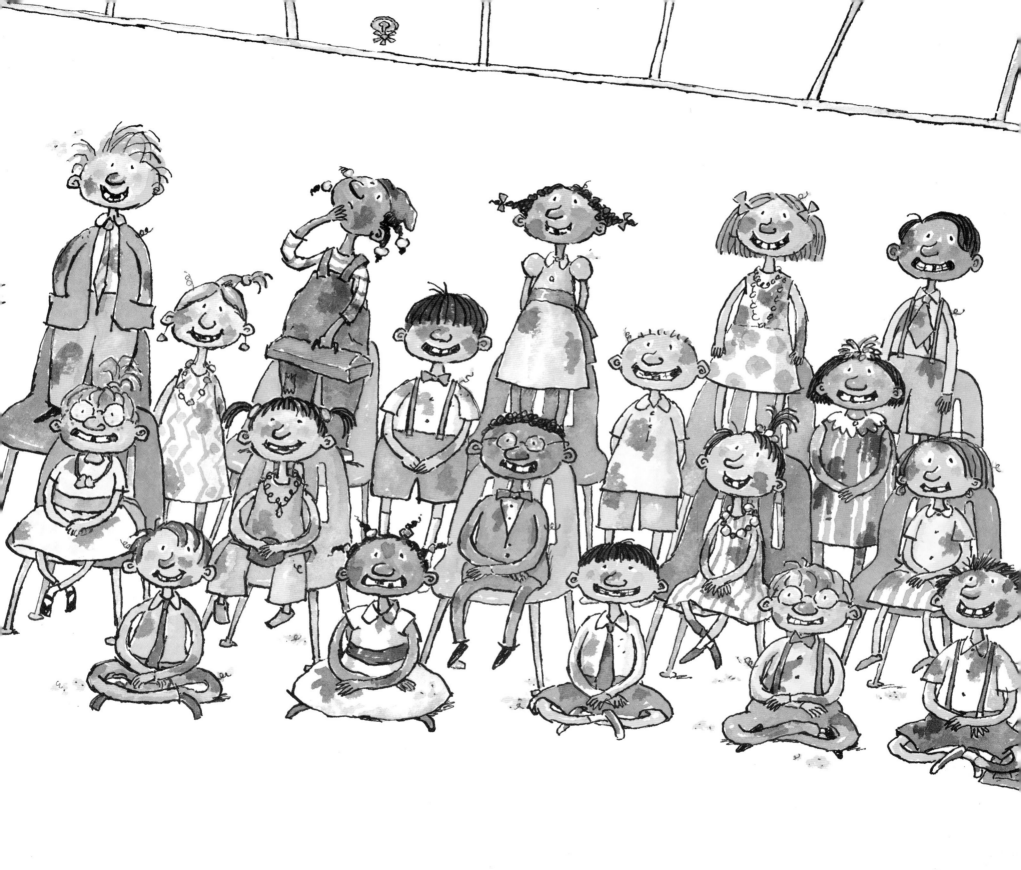

Josephina lifted up a ceiling tile and muttered,
"Hmmm. I wonder how this sprinkler system works."

PUSH SHOVE PWOOSH ABOVE

After some highfalutin fidgeting, fiddling, fuddling,
and foopling, Josephina finally figured out how the
sprinkler system worked.

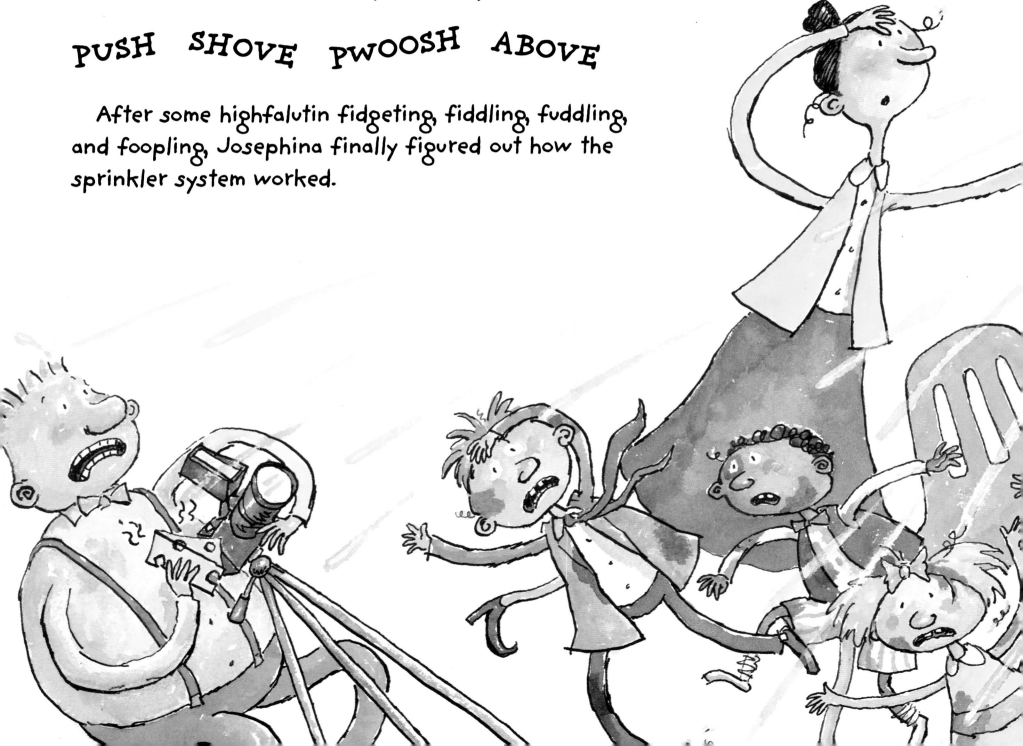

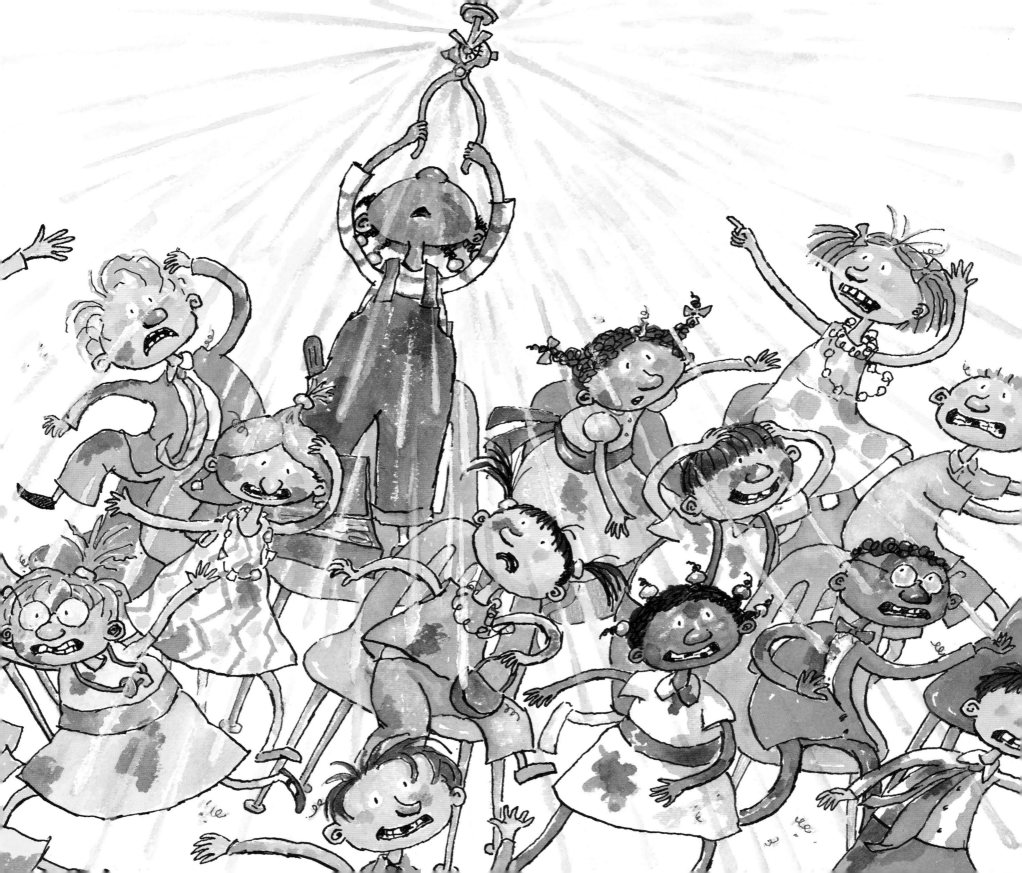

Meanwhile, twenty-two children,
Mrs. Shepherd, and the photographer
wrung out their
 bows and bow ties,
 sashes and suspenders,
 jewels and jackets,
 bun and camera.

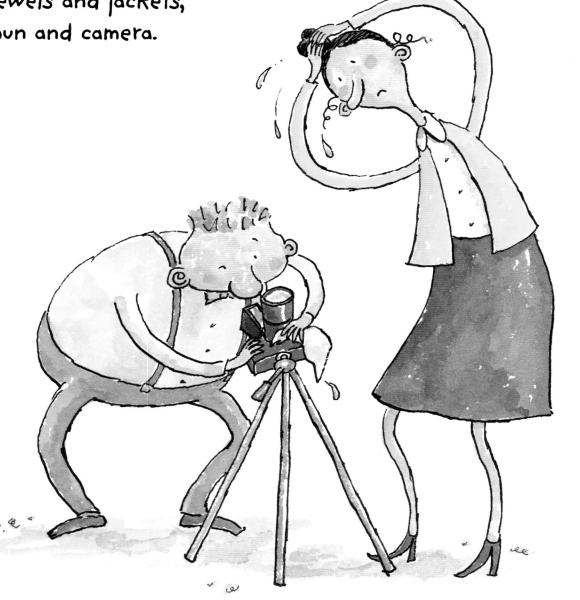

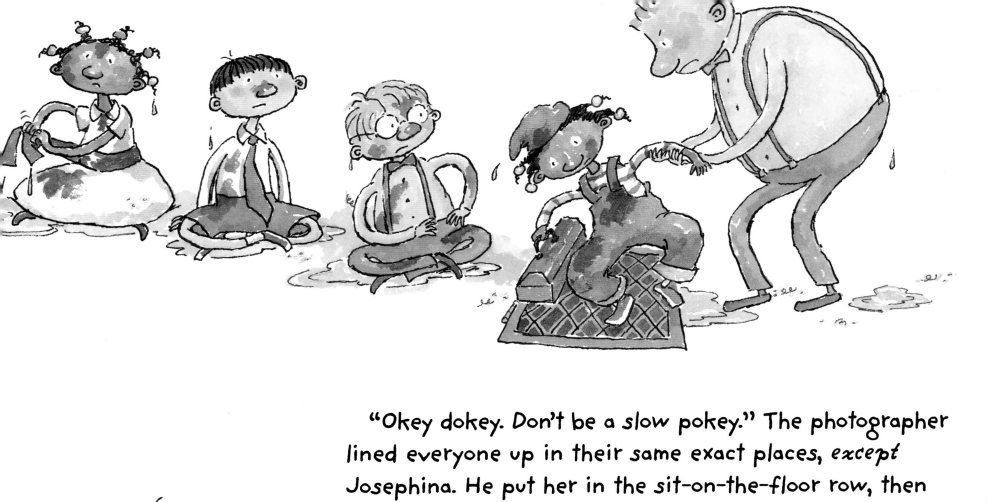

"Okey dokey. Don't be a *slow pokey*." The photographer lined everyone up in their same exact places, *except* Josephina. He put her in the sit-on-the-floor row, then coaxed, "Teethy weethies. Let's see those teethies."

Twenty-two children and Mrs. Shepherd showed their teethies.

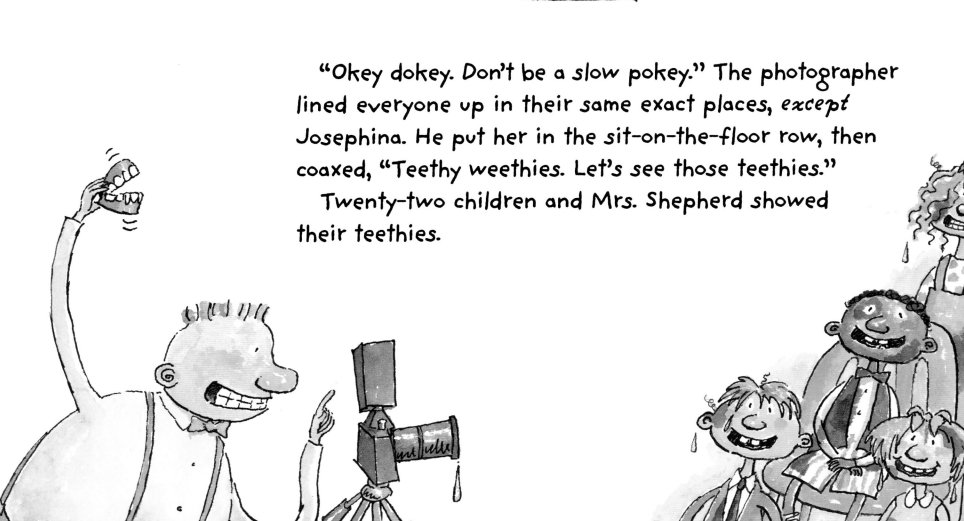

But Josephina had more important things to think about.

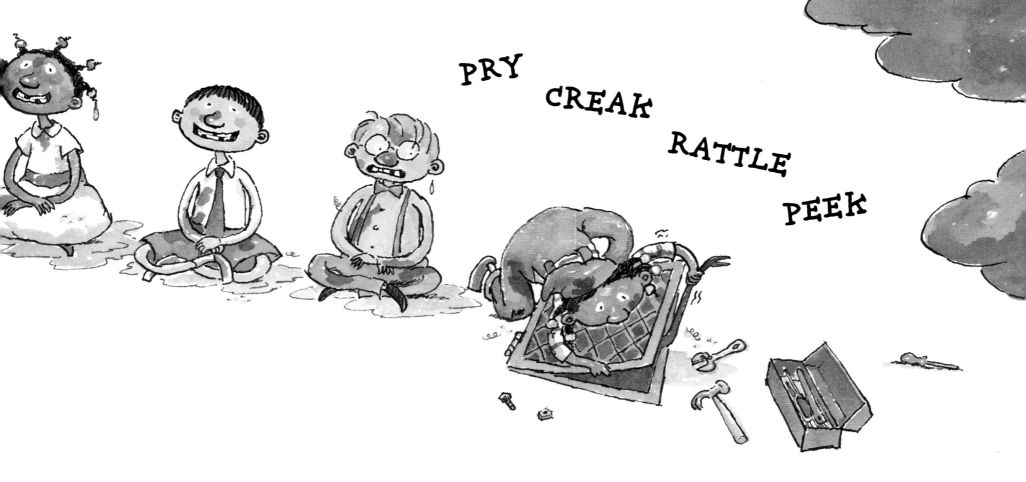

PRY
CREAK
RATTLE
PEEK

Josephina lifted up a floor vent and muttered,
"Hmmm. I wonder how this heating system works."
After some highfalutin fidgeting, fiddling, fuddling,
and foopling, Josephina finally figured out how the
heating system worked.

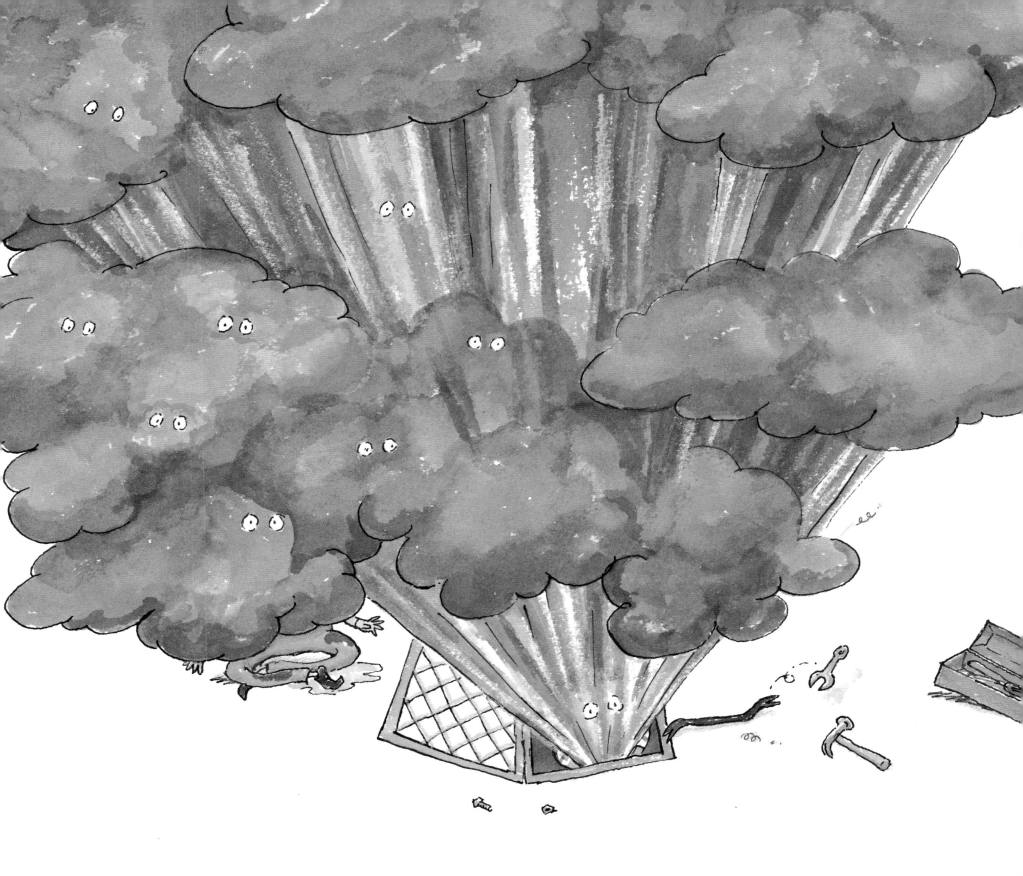

Meanwhile, twenty-two children,
Mrs. Shepherd, and the photographer
stomped the soot off their
 bows and bow ties,
 sashes and suspenders,
 jewels and jackets,
 bun and camera.

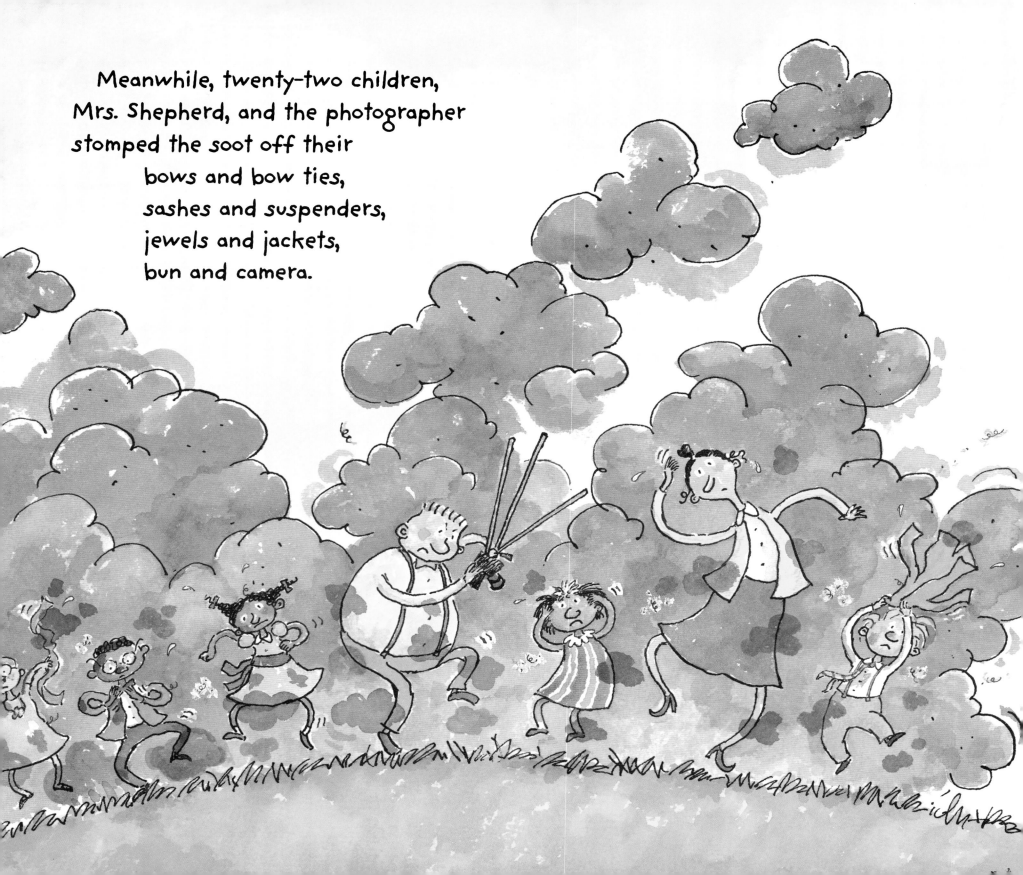

"One more time, you sweetie pies. Just watch my little birdie." The photographer got out his special windup, flashing, squawking, talking bird and lined everyone up, back in their same exact places, *except* Josephina. He put her in the sit-on-the-chairs row, then begged, "Birdie wants a cheesy cheesy. Me-sy wants a cheesy cheesy too."

"Cheesy cheesy, cheesy cheesy," went twenty-two children and Mrs. Shepherd.

But Josephina had more important things to think about.

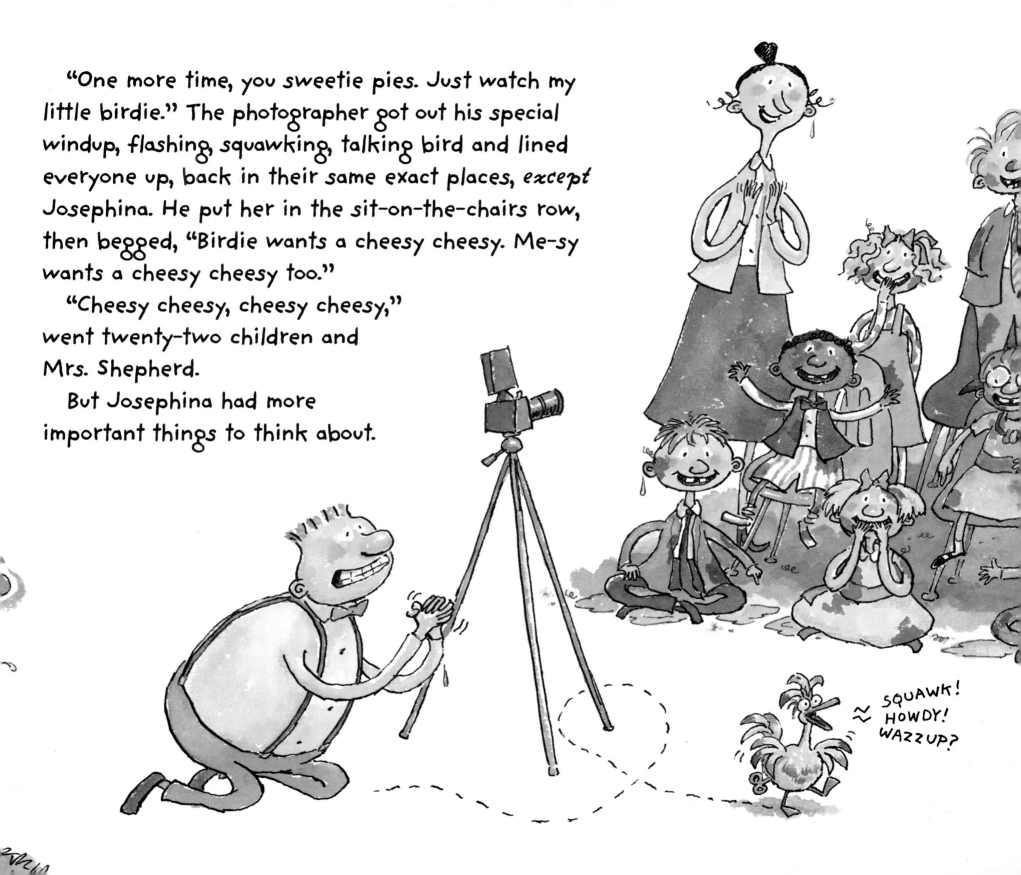

SQUAWK! HOWDY! WAZZUP?

Josephina sat in her chair, muttering, "Hmmm. I wonder what makes this special windup, flashing, squawking, talking bird work."

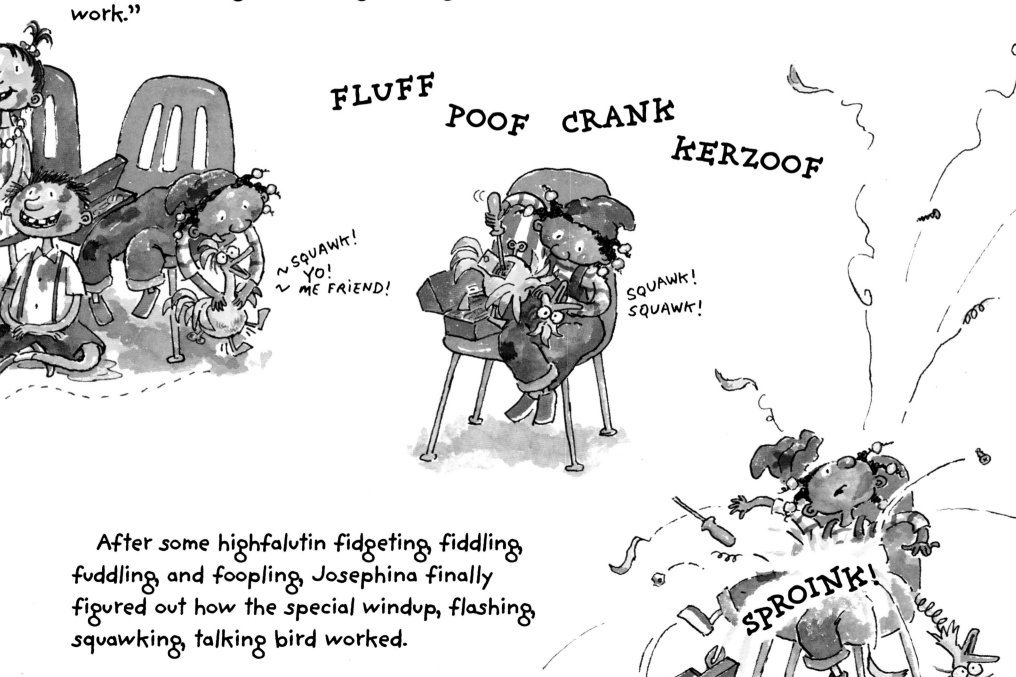

FLUFF POOF CRANK KERZOOF

SQUAWK! YO! ME FRIEND!

SQUAWK! SQUAWK!

SPROINK!

After some highfalutin fidgeting, fiddling, fuddling, and foopling, Josephina finally figured out how the special windup, flashing, squawking, talking bird worked.

Meanwhile, twenty-two children,
Mrs. Shepherd, and the photographer
plucked feathers off their
 bows and bow ties,
 sashes and suspenders,
 jewels and jackets,
 bun and camera.

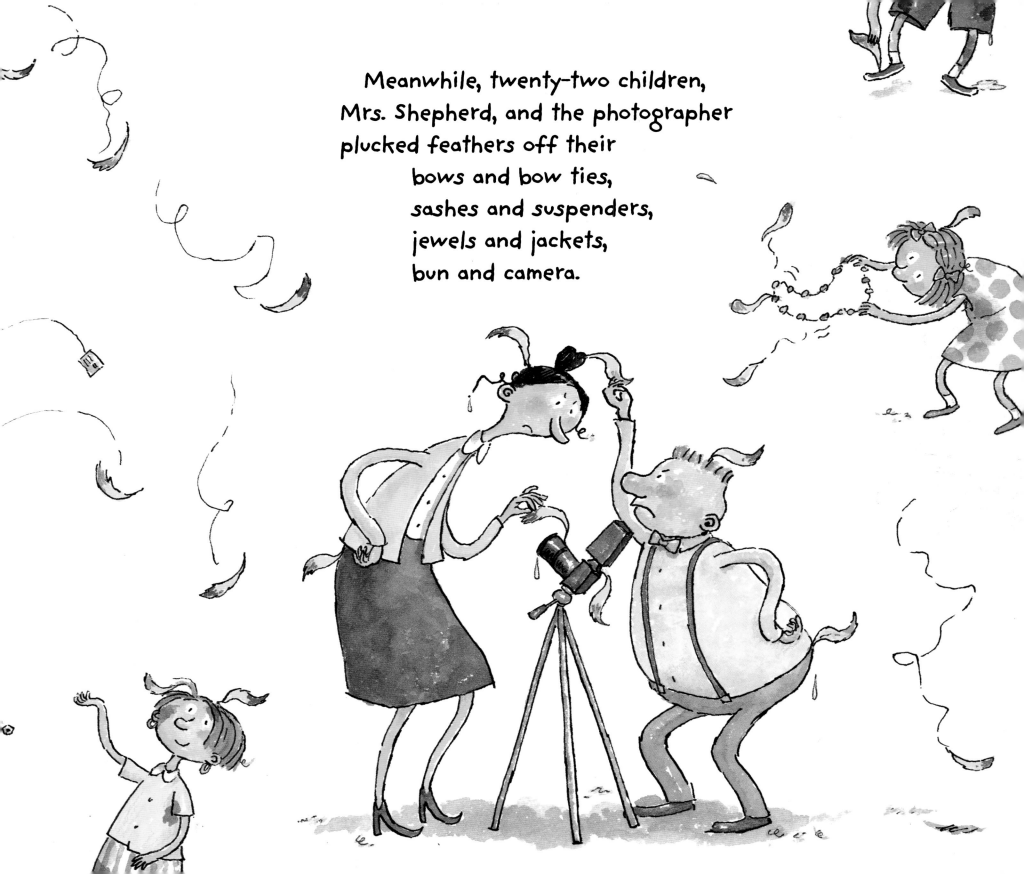

"FREEZE! I SAID, FREEZE!"

The photographer yelled so loud, everyone could see all the way down to his toe bones.

This time Mrs. Shepherd and twenty-*three* children froze. No cheesies. No teethies. But they were *all* looking at the camera. The photographer hurried to push the button.

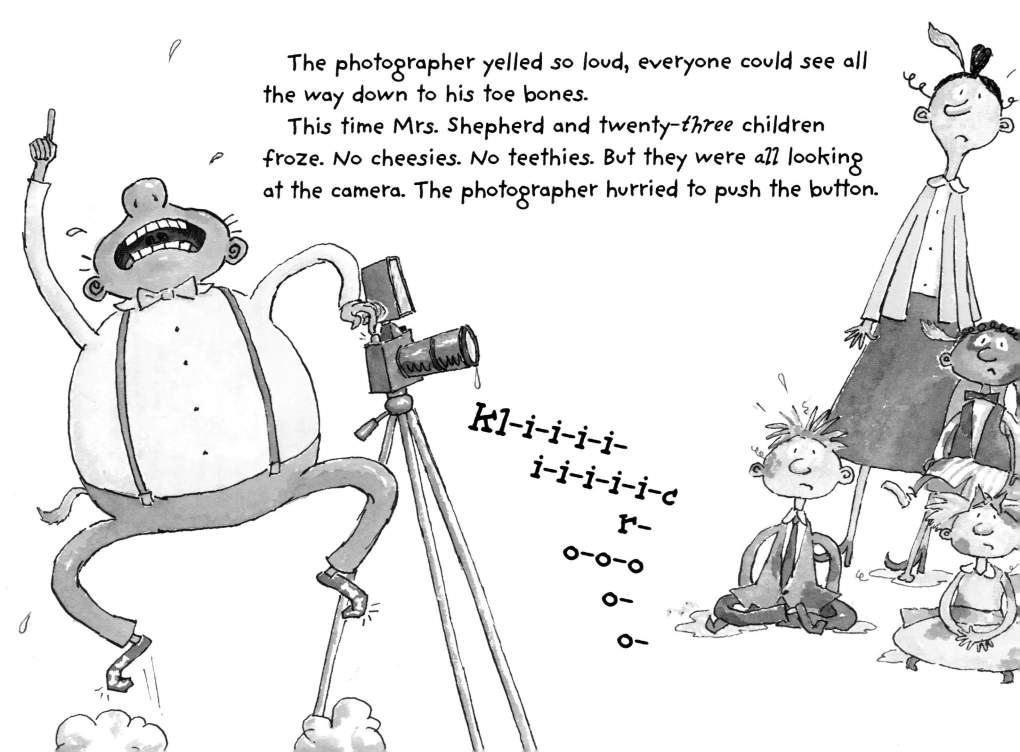

Kl-i-i-i-i-i-i-i-i-i-c
r-
o-o-o
o-
o-

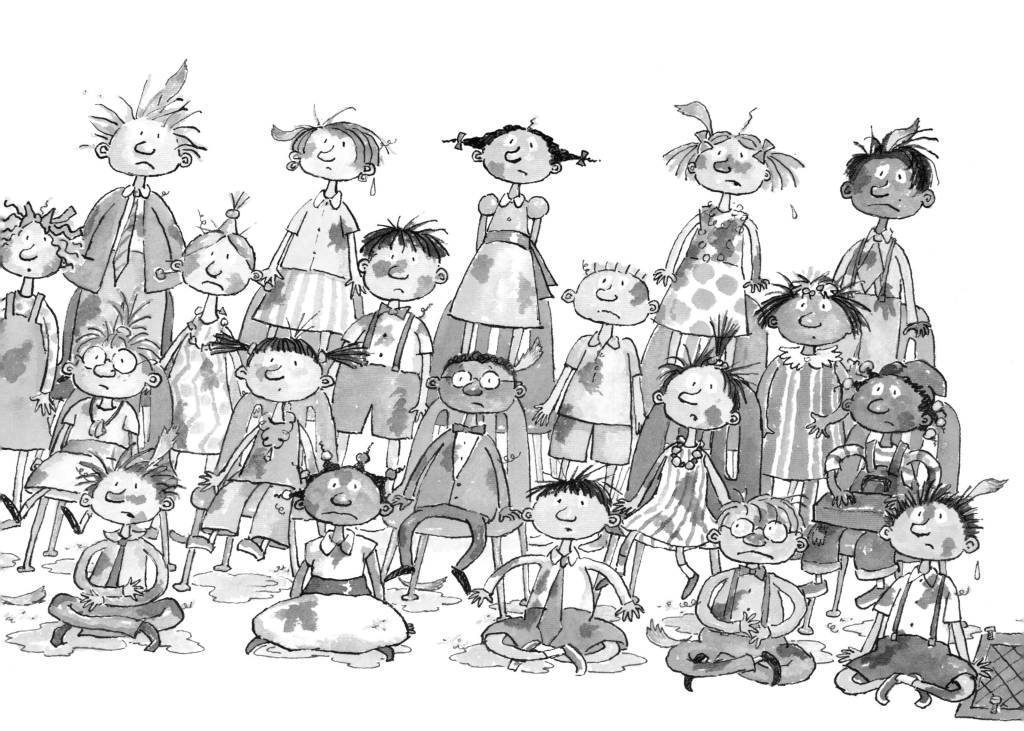

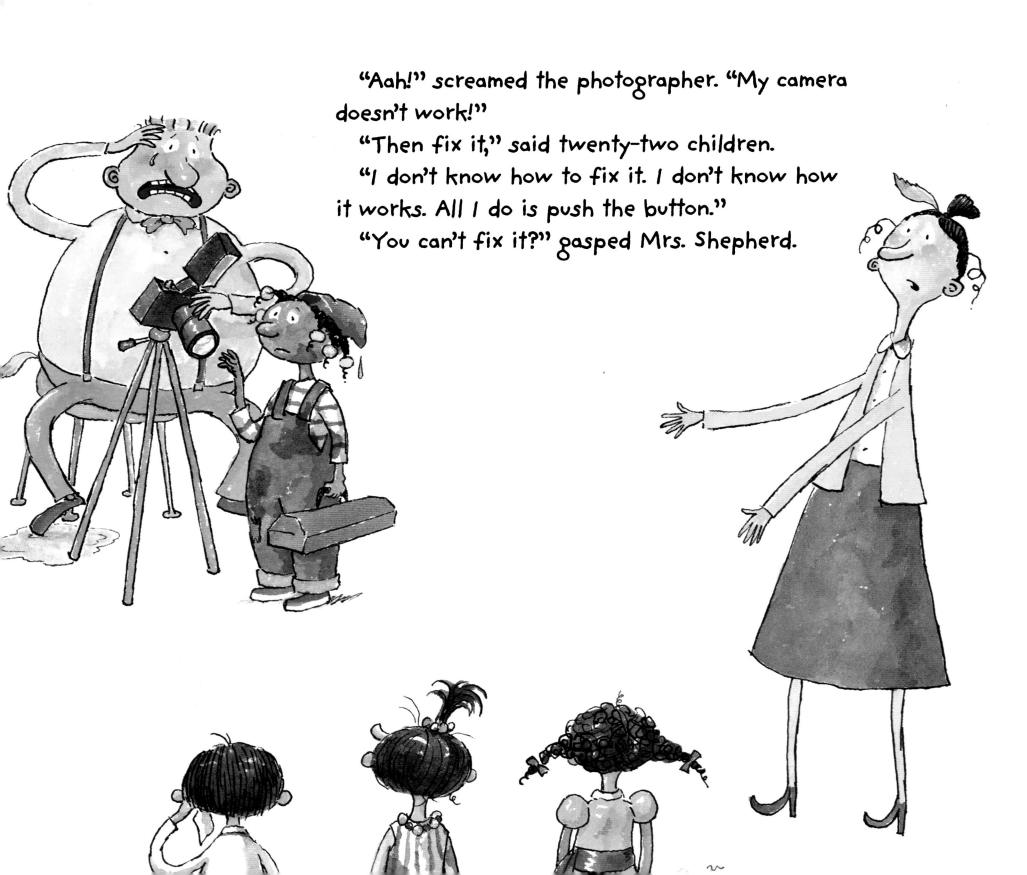

"Aah!" screamed the photographer. "My camera doesn't work!"

"Then fix it," said twenty-two children.

"I don't know how to fix it. I don't know how it works. All I do is push the button."

"You can't fix it?" gasped Mrs. Shepherd.

"We won't have our school picture taken?"
Twenty-two children sobbed.

"No-sy wo-sy." The photographer shook his head.

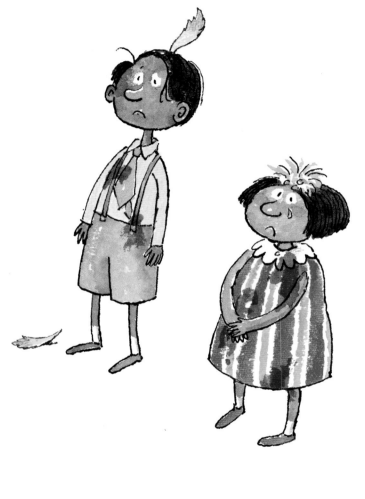

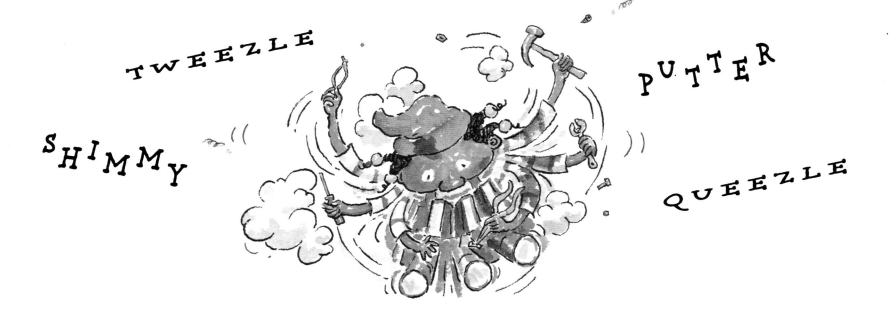

TWEEZLE

SHIMMY

PUTTER

QUEEZLE

Josephina held the camera, muttering, "Hmmm. I wonder how this camera works."

After some highfalutin fidgeting, fiddling, fuddling, and foopling, Josephina finally figured out how the camera worked.

"It works," said Josephina.

"Nice fiddling." Mrs. Shepherd smiled.

"Sweetie, munchkin, pumpkin pie. Show me! Show me!" begged the photographer.

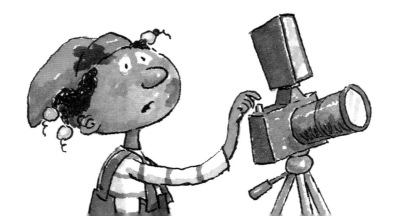

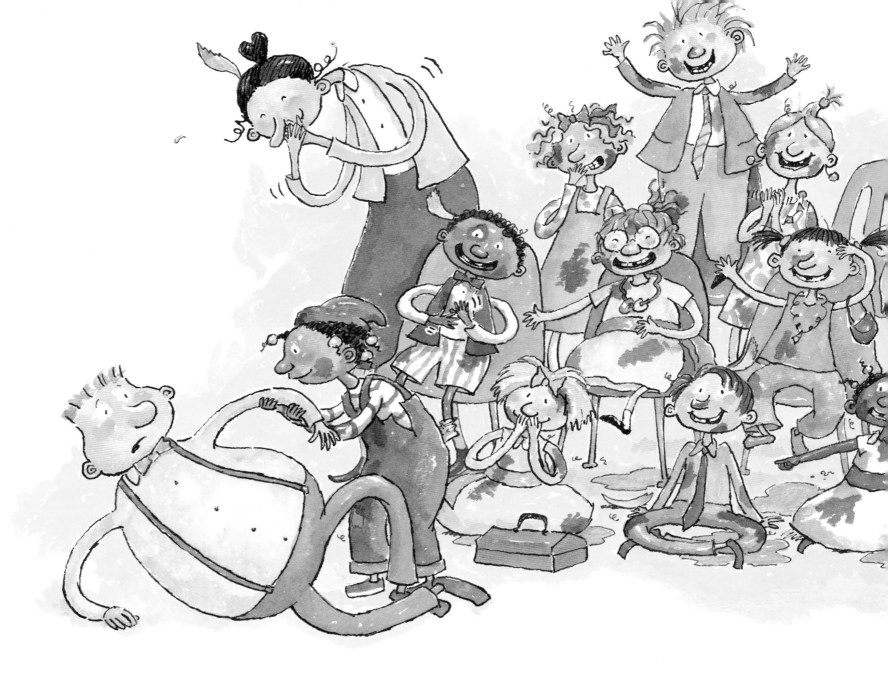

"Okay," said Josephina. She lined everyone up, back in their same exact places, *except* the photographer. She put him in the lie-on-the-floor row.

Then she pushed the time-delay button on the camera, ran to her place, and simply said, "Smile." Twenty-three children, Mrs. Shepherd, and the photographer all smiled.

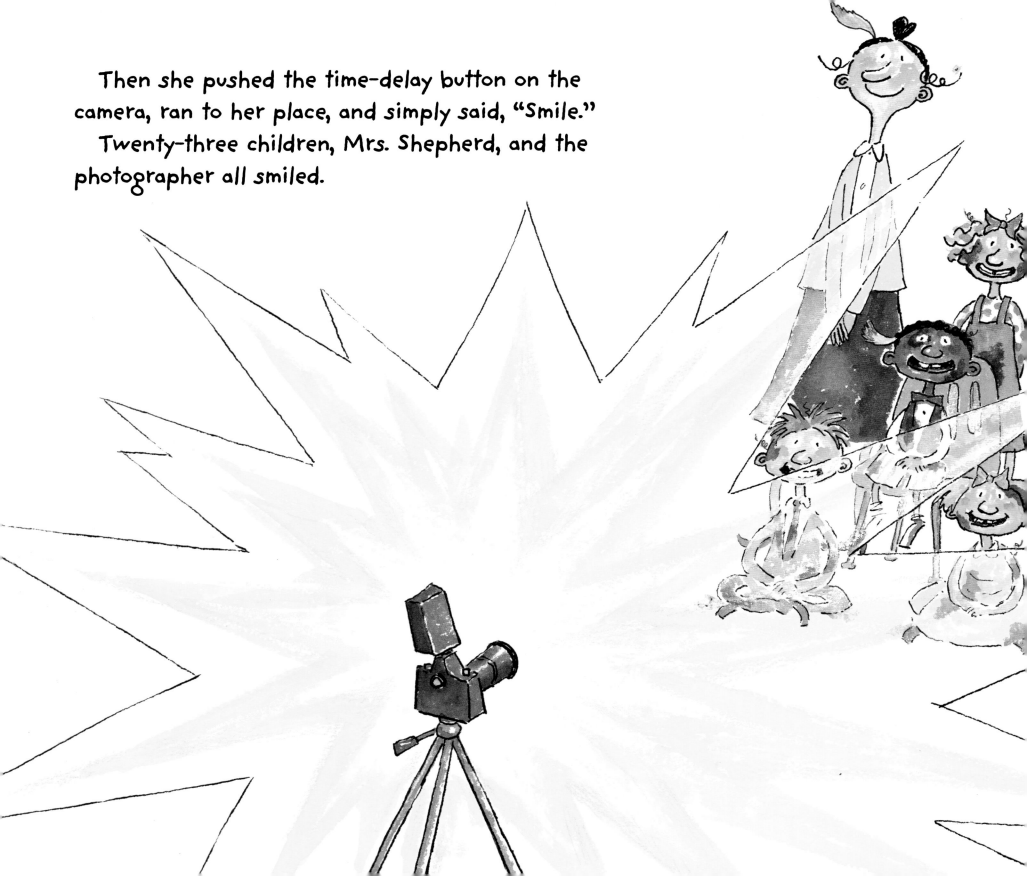

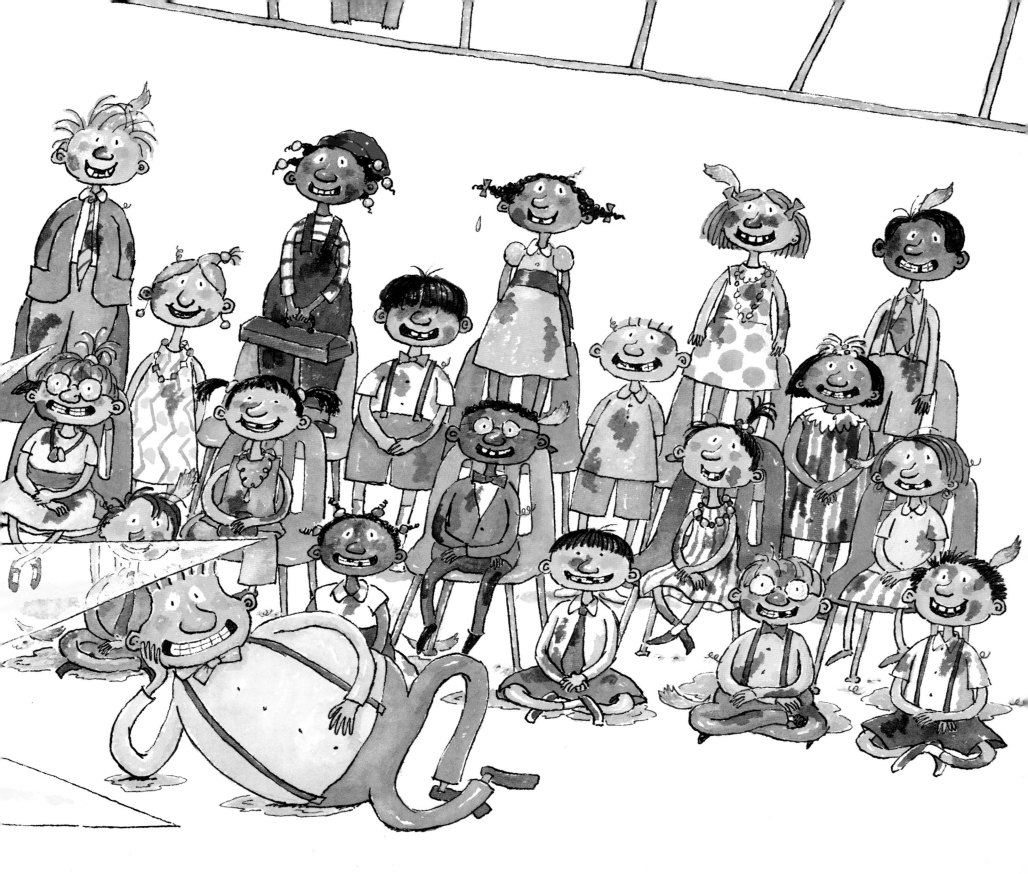

Several weeks later, the school pictures arrived. Mrs. Shepherd asked Josephina to hand them out. Josephina had more important things to think about—like her new spaceship science project—but she passed them out anyway.

Everyone was pretty pleased. But all the parents did wonder: Who was that new big kid in Mrs. Shepherd's class?

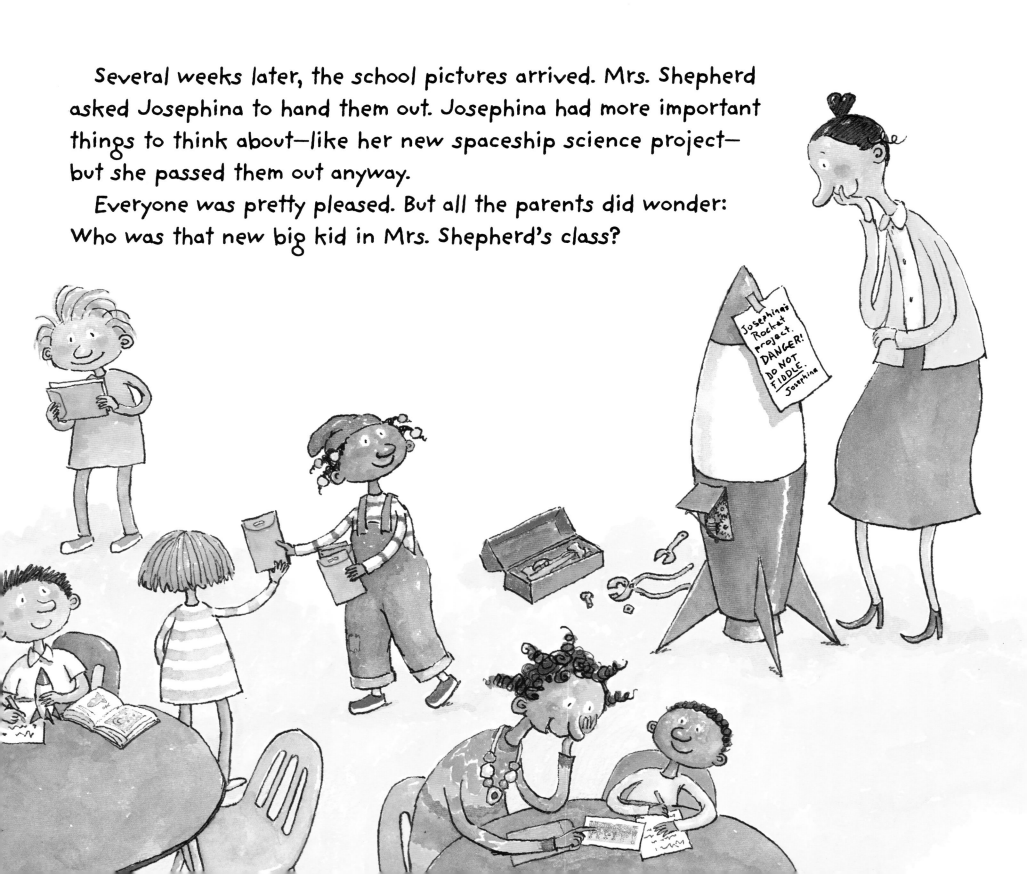

Josephina's Rocket project. DANGER! DO NOT FIDDLE. Josephina

"CHEESY WHEEZY!"

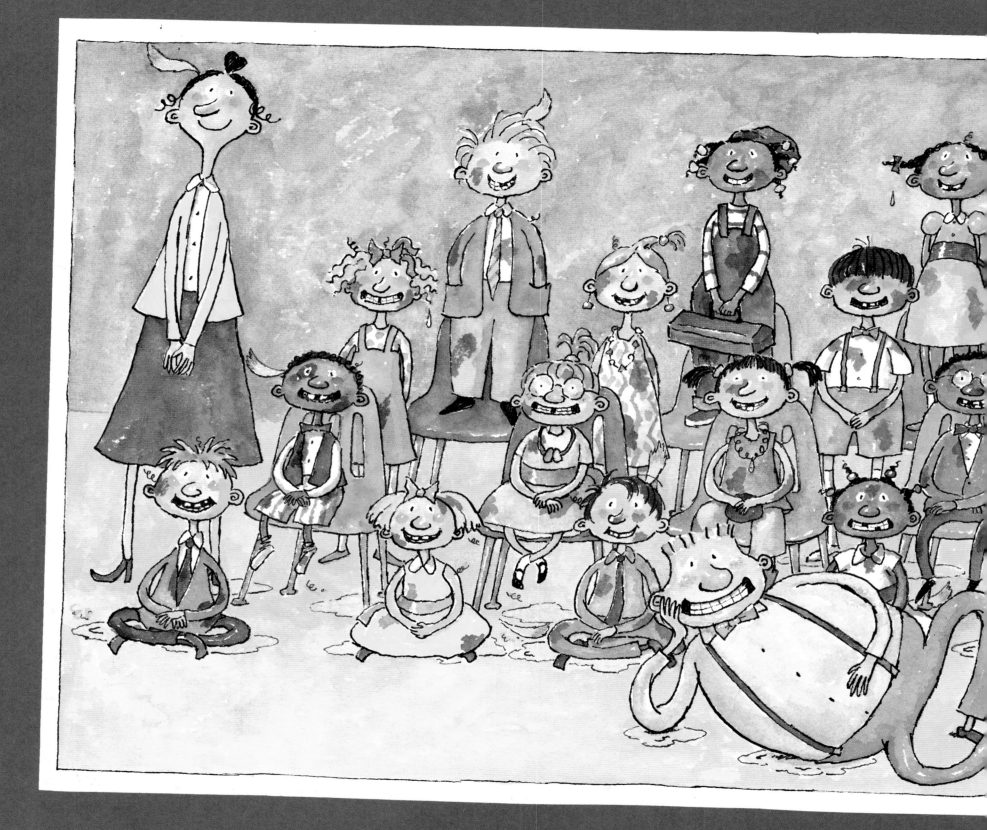